DogKu, CatKu
and
WhatHaveU

SNAPPY LITTLE SENRYU ABOUT AND BY
ANIMALS

by Michelle Shy

Illustrations by Roxanna Groves

COPYRIGHT

Copyright © 2011 by Michelle Shy

Published by Michelle Shy http://www.MichelleShy.com

First Edition 2011

Illustrations copyright by Roxanna Groves

Cover design by Tatiana Vila

Cover art by Roxanna Groves

Editing by Sandra de Helen

The following poems previously appeared in **SnarkyKu** by Michelle Shy:

- Senryu 99
- Senryu 217
- Senryu 259
- Senryu 260
- Senryu 427
- Senryu 433
- Tanka 77
- Tanka 90

ALL RIGHTS RESERVED. This book contains material protected under International and Federal Copyright Laws and Treaties. Any unauthorized reprint or use of this material is prohibited. No part of this book may be reproduced or transmitted in any form or by any means, electronic or mechanical, including photocopying, recording, or by any information storage and retrieval system without express written permission from the author / publisher.

ISBN-13: 978-1467940214 | ISBN-10: 1467940216

THANKS

For Aviva, Bold Girl, Butterball, Che, Chirpy, Digger, Emilio, Emily, Forty Four, Freeway, Georg, Goldie, Justy, Lady, Man Man Foo, Nadia, Naked Tiny Baby Bird, Orange Friend, Phoenix, Pinky, Pretty Girl, Rover, Samson, Shadow, Shepherd Puppy, Smoke, Tuffy and Tui.

Michelle Shy

READER PRAISE FOR SNARKYKU

"Michelle Shy's senryus have a combination of intense impact, incisive commentary and poetic craft that sets her work apart."

"Reading it is like eating Oreo cookies, hard to stop."

"...intelligent, funny, entertaining, and moving."

"This delightful book will have you posting some of its haikus on your refrigerator and sending others to friends -- and enemies; especially enemies."

"Once I started, I couldn't put it down. I kept thinking, I will just read one more, into the night."

"Please, do not deprive yourself of another week of life lived without this gem on your coffee table."

"You'll laugh, you'll cry! You will smile at these bittersweet witticisms."

"... revels deliriously in its love of language and sense of parody, all the while exposing the ridiculous ways in which we have chosen to treat each other and squander our potential."

TABLE OF CONTENTS

Reader praise — 2

Introduction — 5

Chapter One: Cats Voice Their Opinions — 8

Chapter Two: Dogs Butt In — 16

Chapter Three: Michelle Speaks of Cats — 19

Chapter Four: Michelle Complains about Cats — 27

Chapter Five: Dogs and Cats Mix it up with Humans — 32

Chapter Six: Michelle Talks about Dogs — 38

Chapter Seven: Michelle Attempts to Speak to Dogs — 46

Chapter Eight: Chat of Random Creatures — 49

About the Author — 53

Free Dirty Little Sneak Peek into My Next Book — 58

Michelle Shy

ILLUSTRATIONS

My Bed	*cover*
Redheaded Step Cat	*8*
Mine	*16*
Persian Dreams	*19*
Lavender Fields	*27*
My Ball	*32*
My Pool	*38*
Yellow Dog Waits	*46*
Fox	*49*

INTRODUCTION

What the heck is senryu? Why am I calling some of these poems senryu, some haiku and some CatHaiku or DogHaiku? What's a micro-poem? What, for goodness sake, is doggerel? And why isn't there "catterel"?

Haiku: *I figure you already know what haiku is or you wouldn't have purchased a book of haikus. So I'm not going to explain it here. If you really need to know, buy my first book,* **SnarkyKu**, *and read the excellent introduction there regarding the elements of haiku.*

Senryu: *It looks like haiku, and you can beat it out like haiku, but it's not pretty and calm, nor is it about nature. No, instead it's about human reactions or humans within nature and it's a bit more down-to-- earth—perhaps harsher—than haiku.*

In this book, I have called the poems written by me senryu or haiku. If the poem was written by a four-legged friend, I have called it CatHaiku or DogHaiku. (You're aware that the pets didn't really write these, right?)

Tanka: *It ought to be a 5-line poem that starts like a haiku or senryu (5 syllables, 7 syllables, 5 syllables) and then finishes with two lines of 7 syllables each.*

Michelle Shy

But....

*Some English-language haiku poets didn't have their coffee in the morning, so they write 5-line poems without counting the syllables or paying attention to the two-chapter construction of a traditional tanka. They call the resultant word cluster **Gogyokha**.*

*And then, of course, there is **kyoka**. This form is structured like tanka, but it is, like senryu, not about nature. Rather, it's jokey and irreverent. M. Kei, a well-known American tanka poet, calls kyoka "anti-tanka."*

Limerick: *You know limericks. They are those dirty, smutty, rude and juvenile little ditties with a rhyming pattern of AABBA and a very lyrical regularity of rhythm. You know limericks. You repeat limericks when you're smoking.*

Doggerel: *I had to look this one up so that I wouldn't mislead you. It's crude and juvenile humor, as is the limerick, but doggerel has no regular structure. Those who write doggerel toss the rhymes in where they will, and they twist the meter shamefully.*

So now we move from bad to worse.

Catterel: *Please. You knew I made that up, right?*

Micro-poem: *Lazy. You write words. You call it a poem.*

DogKu, CatKu and WhatHaveU

DEDICATION

To all the animals I could not save. You haunt me every day.

Michelle Shy

CATS VOICE THEIR OPINIONS

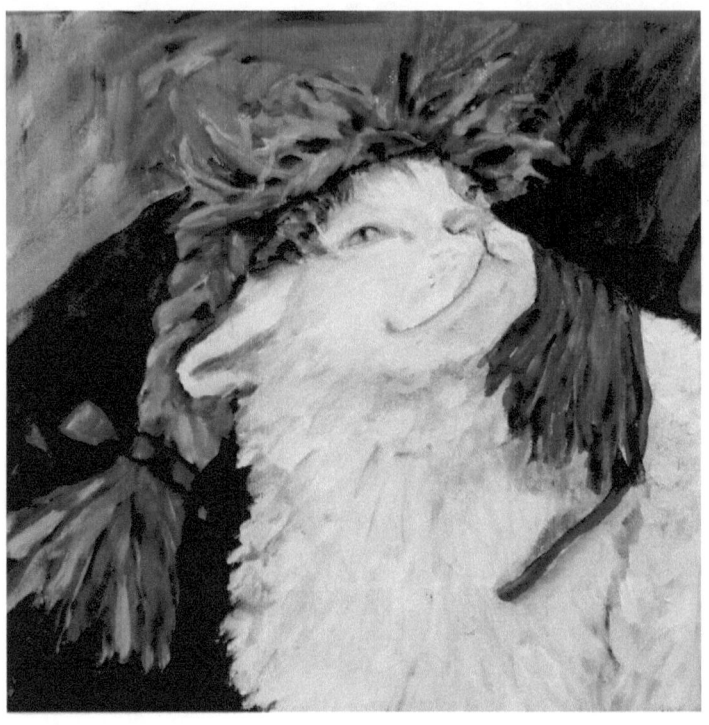

Matilda, the Red Headed Step Cat

CATHAIKU 42
Scratch my ears, my chin
Rub my belly, sternum, left hip
Hey, quit kissing me

CATHAIKU 45
Help me! A monster
It can't be true: looks like Mom
With toenail clippers

CATHAIKU 46
Please clean up my poop
And keep my bowl filled with food
But don't bother me

CATHAIKU 47
Take a number please
After I lick my asshole
Then I will kiss you

CATHAIKU 48
Hey, this seat is mine
Get off the couch: it's mine too
That's my recliner

Michelle Shy

CATHAIKU 49
Lamb chunks in gravy
I lick up all the gravy
Refuse to eat chunks

CATHAIKU 50
Open a new can
The fresh taste has expired
After the first bite

CATHAIKU 51
Chicken and herring
Also chicken and turkey
But no plain turkey

CATHAIKU 52
Are you going deaf?
I've told you seventeen times
Fresh food at midnight

CATHAIKU 53
I will take two bites
This food bores me. Pick it up
Hey, wait, bring it back

CATHAIKU 54
You want cat lap-sits?
I don't like terrycloth robes
Change into your silk

CATHAIKU 55
Yeah, yeah, go to work
I'll be fine here by myself
Knocking down your books

CATHAIKU 56
You bought me a toy
Well, thanks, just drop it right there
While I play with dust

CATHAIKU 57
Open this window
I like the autumn-fresh breeze
And the smell of birds

CATHAIKU 58
Out, out, hey, get out!
Damn squirrels in my backyard
Disturbing my nap

Michelle Shy

CATHAIKU 59
Stop bothering me
No ear cleaning, no brushing
No toenails, no baths

CATHAIKU 60
Dad's taking a nap
Mom's trying to play with me
Dad! Wake up, let's play!

CATHAIKU 61
Mom, come rescue me
Upset panic terrified
Dad is petting me

CATHAIKU 62
Yikes, you touched my tail
Now I must have a full bath
Lick off the cooties

CATHAIKU 63
Berber nest, tent bed
Crackle bed, condo, tunnel
I'll sleep in the sink

NOTREALLYPOEM 3
To everything there is a season
Now is the time for sitting in the window
Watching birds
It is not the time
For you to pet me

Extremely disturbing photo of Sam the Cat the day he visited the shooting set of *Jo Castle*. Somehow he ended up in the makeup trailer, wearing #49 Blackberry.

CATTANKA 144
Yes, I did hear you
Calling my name for hours
From twilight to dawn
Seeking me under bushes
But I was busy hunting

Michelle Shy

CATHAIKU 64
Momma, help me, Mom
That man who lives here with us
Trying to pet me

CATHAIKU 65
Bubbling cat fountain
Charcoal-filtered H2O
Toilet water's better

CATHAIKU 69
Dear humane shelter
How do I file a complaint?
Mom kisses too much

CATHAIKU 124, *in honor of Tuffy*
Scratch my forehead. More.
Good. More. Now whiskers. Now stop
Or I will bite you.

CATHAIKU 575
You're my best snuggle
I want to be glued to your side
Hey, no petting me!

CATHAIKU 580
I ate seven mice
Didn't want intestines
Left them on your desk

CATHAIKU 619
See that half-filled bowl?
What if there's an earthquake soon?
You'd better fill it.

VERY ODD HAIKU 116
Purr, purr, rub, knead, lick.
I'm off your lap. I'm back on.
OrangeKittenKu.

Michelle Shy

DOGS BUTT IN

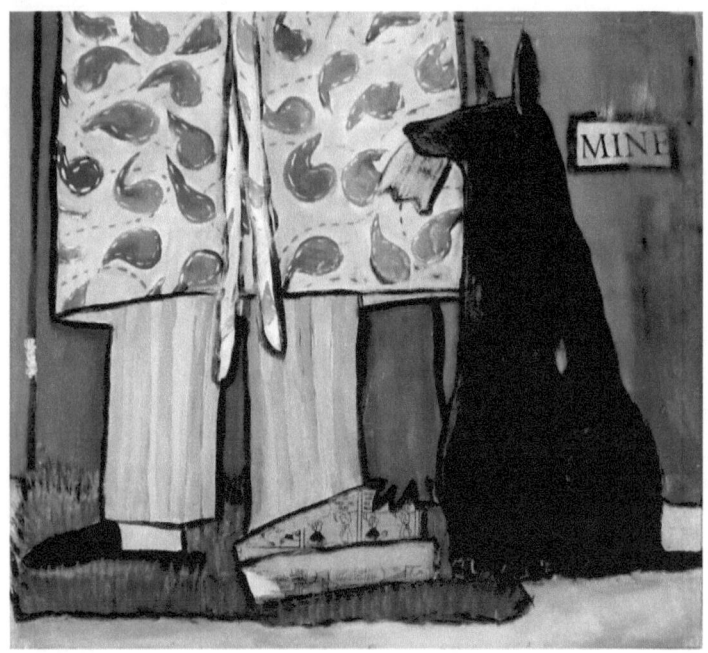

Mine

DOGHAIKU 226
Selective hearing.
"Dinner," quite clear. But, "Down, stay,"
I don't understand.

DOGHAIKU 227
"No, I did not eat
The neighbor's rooster. Did not!
I am 'Good Dog Lady.'"

DOGHAIKU 259
She: Please stop snoring.
He: Am I bothering you?
Dog: You bother ME!

DOGHAIKU 263
They left me alone
I hate to be left behind
Guess I'll eat this chair

DOGHAIKU 383
Opinionated
I shove you off of the couch
You may call me "Dog"

Michelle Shy

DOGHAIKU 385
I whine for handouts
Cheetos are my favorite
Bury them out back

DOGHAIKU 386
Football on TV
Dad is sharing his sandwich
I'm thumping my tail

DOGHAIKU 617
Human gave me hat
Stupid hat with antlers on
I'm plotting revenge

MICHELLE SPEAKS OF CATS

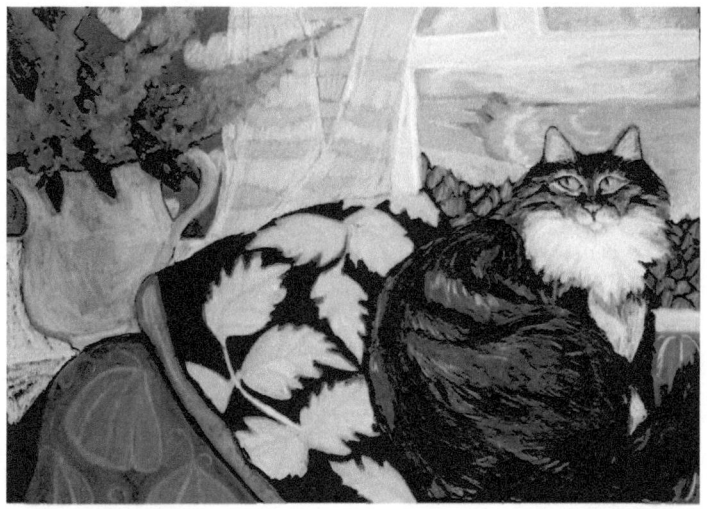

Persian Dreams

Michelle Shy

STAR TREK SENRYU 500
Far in the future
Data teaches at Cambridge
And has seven cats

STAR TREK SENRYU 501
Cats in the future
Still will not have been well trained
Spot! Get down from there.

STAR TREK SENRYU 179
Star Trek TNG
Recurring character Spot
Smart cat. Pretty too.

STAR TREK SENRYU 182
Feline supplement
Number 137
For Spot, Data's cat

STAR TREK LIMERICK 34
I wrote this new Star Trek plot
Worf and the blue Mr. Mot
Having sex at the poker game
While Data's gone insane
Trying to disassemble Spot

HAIKU 29
Groundskeeper Larry
Rescued a baby kitteh
Now golf course mascot

HAIKU 30
Motherless bobcat
Cries hungry at driving range
Now he's our Links Lynx

HAIKU 31
Our golf course kitteh
Sits on the water hazard
Spying on fat geese

HAIKU 32
Cat on thirteenth green
What do USGA rules say?
Chip or take a drop?

HAIKU 41
Approach thirteenth green
Sand trap bunkers phosphoresce
Golf Course Cat shitting

Michelle Shy

HAIKU 43
Cat on thirteenth green
Stretches his paw towards the cup
All these balls are mine

SENRYU 43
It's housecleaning day
Time to vacuum all the cats
Faster than brushing

TANKA 119
EmCat's six kitties
Behind the washing machine
Dusty dark moldy
I moved them to a sunspot
Em dragged them back to her cave

SENRYU 705
EmmyCat's crouching
At the end of the hallway
Smacks me when I pass

HAIKU 333
FinCat chased the bug
Now he's hanging by one paw
From a ceiling beam

HAIKU 334
Sunlight climbs the wall
From the floor to the ceiling
FinCat follows it

HAIKU 335
FinCat attacked Georg
Poor old slow Georg sunbathing
Finny beat him up

HAIKU 336
ManManCat spent months
In the cellar hangin' buds
With Norwegian Rats

HAIKU 579
Back porch at dawnbreak
Raccoon-battered PhoenixCat
Smiling his ass off

HAIKU 44
When he got older
No longer a hell-raiser
He became a lap cat

Michelle

You can't force cats to cuddle if they don't want to

Unless they're really feeble, elderly cats.

Like Comment Yesterday at 9:55am

HAIKU 1
Cats gulp blades of grass
Humans broccoli or corn
When they need to poop

GOGYOHKA 1
In bed
Husband
In the kitchen
Kitty and me
Cuddling

SENRYU 170
Crash! At 3 a.m.
The cat's on the chandelier
Throwing light bulbs down.

HAIKU 716
At night I'd whistle
The kitties would come leaping
Through the back window

SENRYU 718
Those kitties were sweet
They invited a thin stray
To eat at my house

SENRYU 719
Roses in attics
Kitties live in crap basements
Cold wet garages

SENRYU 720
Orange stray
Sneaked in my cat door to eat
I couldn't touch him

SENRYU 686
Hubby's pretending
We're not getting a kitteh
Head-in-sand syndrome

Michelle Shy

SENRYU 828
Cat adoption fee
Seventy-seven dollars
Six dollars per pound

SENRYU 668
Tiny lost kitty
What shall we name the baby?
Comrade Spike the Cat

SENRYU 816
Don't rub the cat's dick
It makes him get all frisky
Knocks the china down

MICHELLE COMPLAINS ABOUT CATS

Lavender Fields

Michelle Shy

SENRYU 848
I was Somebody
Everyone kowtowed to me
Except my cat Sam

SENRYU 56
Won't let me pet you?
OK, then, don't rub my legs
Don't purr in my lap

SENRYU 378
Thanks for the mouse guts
We admire your hunting skills
Now get them out, please

SENRYU 379
Mister Kitten Cat
Please invite your raccoon friend
To leave our bedroom

SENRYU 260
Ten thousand years back
We domesticated Cat
And coined the word "pest"

DogKu, CatKu and WhatHaveU

TANKA 2
Daddy fed Onyx
Onyx told Mom he's famished
So then Mom fed him
Now Onyx complains to Gram
So hungry, I'm so hungry

SENRYU 421
Do, re, mi, fa, sol.
Practicing my scales. Why, then,
Is the cat yowling?

SENRYU 823
Dear humane shelter
The cat we got was no good
He only speaks French

Michelle Shy

SENRYU 817
Dear humane shelter
I want to trade in my cat
For one who poops less

Michelle
My cat wouldn't sit in my lap, so I pulled his tail.
 Like · Comment · Yesterday at 9:55am via HootSuite

SENRYU 818
Dear humane shelter
Please send me a different cat
This one has bad breath

SENRYU 822
Dear humane shelter
Really quite by accident
I ate the whole cat

SENRYU 819
Dear humane shelter
The cat I got was no good
Chat au bourguignon

SENRYU 827
Dear humane shelter
I fed herring to the cat
Now the cat stew's spoiled

KYOKA 145
Dear humane shelter
May we have another cat?
We loved the first one
He was so sweet and pretty
In a stew with lentil beans

Michelle
Sammy Cat, you are a pest and no one likes you. Eat your dinner and quit crying.

 Like · Comment · Yesterday at 9:55am via HootSuite

DOGS AND CATS MIX IT UP WITH HUMANS

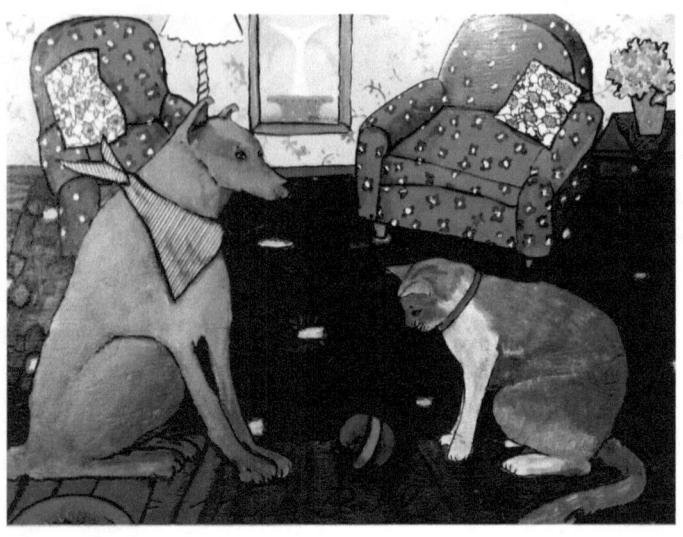

My Ball

DOG TANKA 129
Bark, bark. Cat! Get down!
We have a rule in this house
No dogs on the couch
I constantly break the rule
But I want cats to obey

HAIKU 9
Four senior kitties
Enjoying the fire
Fat pup sits on them

SENRYU 25
Warm cat near my throat
Puppy under the covers
Blood pressure sinks down

CATHAIKU 754
I'm taking a break
I did not come in this room
Solely to swat Dog

SENRYU 47
Family budget
Pets eight hundred fifty bucks
Humans twelve ninety-nine

Michelle Shy

SENRYU 151
Seven cats, four dogs
Everyone slept on the bed
My legs are cramped now

LIMERICK 2
I tried to get into bed
Soothe my body and aching head
A terrier, Great Dane and parrot
Plus two bunnies sharing a carrot
Had taken my place instead

SENRYU 193
Please don't bark at night
To warn us that the cat is
Waking up to pee

CATHAIKU 225
O, hai, U foundz me.
Goggie has big slash on face?
No, it wuzn't me.

HAIKU 717
EmCat near the door
Left paw raised, green eyes steady
Whacks dogs going by

HAIKU 376
Five dogs, seven cats
Crowded on a king-size bed
No room for humans

LIMERICK 45
Cats mating with high-pitched screams
Interrupting my pleasant dreams
Finally they quit, but it's always something
Now the squealing of two dogs humping
Four-leg red-light district, it seems

SENRYU 377
Trying to squeeze pets
Twelve in the car all at once
Vaccination time

TANKA 127
Kitties liked to lounge
On the seat-back of the couch
Which incensed the dog
Who was repeatedly told
No dogs allowed on the couch

DOGHAIKU 384
I'm ignoring you
Cats don't deserve to exist
I, Dog, am the queen

Michelle Shy

HAIKU 391
EmmyCat denies
Hitting the dog, yet she clasps
A tuft of dog fur

HAIKU 392
NatDog is confused
It's hard to discern...this cat...
...sibling or dinner?

NOTREALLYPOEM 1
Budget meeting
Kitchen table
Hubby, me, dogs, cats
Dogs waited on chairs hopeful for treats
Cats never stayed till adjournment
Same argument every month
Budget budget budget
One month we recorded it
After that
First of every month
We made the dogs and cats sit through the tape
And we left
Went on a date
It worked for seventeen years till all the cats died
Now we are forced to hold another budget meeting

TANKA 136
Black EmCat
Kitchen counter
White NatDog is thirsty
Yelp
White fur in black claw

MICHELLE TALKS ABOUT DOGS

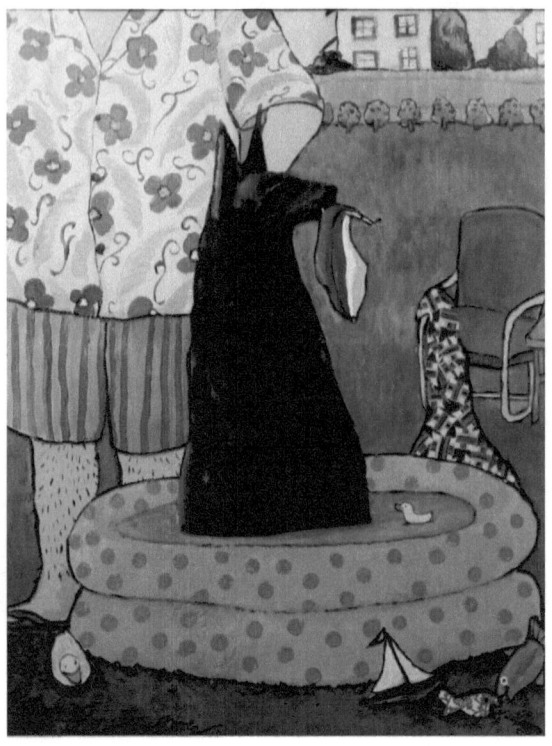

My Pool

HAIKU 21 AND HAIKU 22
Masked fur-face beauty
Contemplates the iced river
Gleefully plunges

She was our sled dog
Athlete who laughed while running
Racing with herself

HAIKU 34
She graduated
Puppy-obedience school
Dead last in her class

HAIKU 39
Dog had noisy farts
Shocked, she turned her sweet fur face
And barked at her ass

HAIKU 66
Dog play position
Excited, wagging his butt
Just like tennis pro

Michelle Shy

Michelle
Dog breath

 Like · Comment · Yesterday at 9:55am via HootSuite

HAIKU 67
Car Chaser got old
Now she barks without running
Semiretired

HAIKU 4
Saturday morning
Fuzzy balls between his legs
Saturday night none

TANKA 128
No dogs on the couch
Natty pretends to comply
While we're in the house
As soon as we leave for work
You-know-who is you-know-where

HAIKU 790
Conclusion: squirrel
I've determined by footprints
My dog by sniffing

SENRYU 46
Family council
Jim and I get one vote each
Barky gets two votes

SENRYU 51
"No dogs on the bed."
"Don't feed dogs at the table."
...That lasted one week.

SENRYU 99
Don't pull the dog's tail
Can't you see you'll make him cry?
Let ME pull his tail

LIMERICK 52
Gonna trade hubby
In for a puppy
Won't complain when I buy new shoes
Or talk during afternoon snooze
And absolutely just as cuddly

LIMERICK 53
In the bathtub soaking in foam
My thoughts can't help but roam
My sweet doggie ran away
I won't wash my asshole today
The scent will lead her home

Michelle Shy

SENRYU 131, in honor of Bo-Wils Arctic Star Nadia
We found our lost dog
She barked that we were to blame
We were negligent

HAIKU 142
At midnight in bed
The dog needs more room to stretch
"Move over," he says

HAIKU 250
Get to bed early
Or your spot will be taken
By three farting dogs

DEMENTED DIALOGUE 9
Supermarket Parking Lot Lady: Your dog is pretty. I used to have a dog like that, but it got too big, so I got rid of it.

Me: I used to have a little blond daughter like that one you have…

HAIKU 222
We have company
Our dog attends the party
Barfing up green worms

SENRYU 266
After I moved out
Our dog growled at all his dates
So he asked me back

TANKA 90
Today I petted
Pyrenees, Greyhound, Scottie
Attached to them
Were three humans
To whom I did not speak

HAIKU 303
Life philosophy
Learned from a wolf-gray husky
Eat. Shit. Get happy.

Michelle Shy

SENRYU 373
Only a puppy
Pink tongue, white belly, black nose
Can be my best friend

SENRYU 374
I'm cramped in a chair
Husband's sleeping on the couch
Dog stretched out in bed

SENRYU 375
Help! Can't move my legs!
I'm dreaming I'm paralyzed.
Dog, get off the bed!

HAIKU 387, 388 AND 389
Midnight. Let out Dog.
She leaps up at the plum tree
Gulping falling fruit.

4 a.m. Dog out.
She squats, plum pits rushing out.
Fruit in and pits out

Plums rush through my dog
In the mouth, out the tailpipe
Repeat tomorrow.

HAIKU 390
I rub her belly
Her back leg kicks and twitches
That's the way she laughs

HAIKU 393
When we were wealthy
We purchased satin dog beds
Dog preferred leaf rot

MICROPOEM 1
Mixed marriages
I have a pit bull
He has a Papillon

TANKA 126
Twisting Highway 1
Tires squealing, gears linking
I'm in the backseat
Picking ticks off NattyDog
Tossing them out the window

KYOKA 1
Halloween dinner
Pumpkins, yams, broccoli soup
Dog's disappointed
Addresses the skeletons:
"I thought there'd be bones."

Michelle Shy

SENRYU 394
On the bedroom floor
In the middle of the night
Paw prints on my butt

SENRYU 581
On Venice Beach
All dogs are either pit bulls
Or pocketbook dogs

TANKA 116
Started the evening
Comfy puffed-up air mattress
Next to me two dogs
Awoke on flat plastic
Dogs lying on top of me

SENRYU 433
My dog eats cat shit;
She has cat-shit breath. I have
Cat-Shit Attitude.

MICHELLE ATTEMPTS TO SPEAK TO DOGS

Yellow Dog Waits

HAIKU 68
Nik barks at the cars
But she no longer chases
Hey, Nikki, chase me

SENRYU 44
Don't embarrass me
By bringing used underwear
To dinner, dear Dog

HAIKU 50
Sit. Heel. Come. Down. Stay.
Hey, don't bite that Pekinese.
You'll flunk dog training!

SENRYU 217
Give me a dog kiss
You sweet little puppy girl
Ewww. Ass breath. Skip it.

SENRYU 221
I'd like to kiss you
Smooch you, hug you, hold you tight
Love you, little dog

SENRYU 224
You drool and slobber
You chew my photo album
Don't you have rawhide?

CHAT OF RANDOM CREATURES

Fox

TANKA 77
Goldfish
Must go
To therapy
He has an aversion
To his new bowl

SENRYU 380
Parrot. Soft feathers.
Warbles in my ear. Cuddles.
Ouch! Nipped me. Quit it.

HAIKU 10
Bald eagles chatting
Douglas fir top, Sauk River
"Stinky dead salmon"

HAIKU 19
Gramineous breeze
Rustling rodents scurrying
Raptor soars above

TANKA 118
Alberton Main Street
Sixteen magpies on the highway
We drive up, they fly
We see no animal corpse
Were they having a meeting?

Michelle Shy

STAR TREK SENRYU 492
Clicking beetles, Spot,
Two scared weasels, a morphed dog.
Non-bipeds are rare.

DOGGEREL 7
Once I romped with the antelope:
Pronghorns cream, beige and taupe.
But that was then and this is now.
They are pissed at me, and how!
When I approach the herd vamooses,
The kids running behind like tiny cabooses.
Those silly, crybaby, four-legged dopes.
So what if I called them cantaloupes?

SENRYU 427
Nasty disgusting
Honeybees having orgies
With multiple blooms

SENRYU 756
Grizzly and two cubs
Forty miles away from here
Do they eat horses?

HAIKU 37
Herd of antelope
Grew from seven to forty
Antelope convention

DogKu, CatKu and WhatHaveU

SENRYU 181
I don't want to live
In an empty, barren world
Devoid of species

SENRYU 204
Why all this hatred?
All animals share the earth.
We all eat, love, play.

ZOMBIE SENRYU 528
If I'm a zombie
I refuse to eat kittens
Humans only, please.

ZOMBIE SENRYU 566
Wake up; it's your turn
Slip out into the alley
Kitty wants kidneys

SENRYU 539
My dog's a zombie
She gnaws on a bone all day
Does that qualify?

SENRYU 576
I'm safe from zombies
Double deadbolts and a dog
I'm not scared.....aaaaaaaaaaaaaaaaaaaaaahhhh. Glug.

Michelle Shy

ABOUT THE AUTHOR

Author photo by Travis Sterner; makeup by Illusions by Melanie

I am a comedian, performance artist, actor, screenwriter, filmmaker and author because a career counselor once told me I'd never be able to hold down a straight gig. This prediction was accurate: I've been fired from 79 normal jobs.

I have twelve cats, seven dogs, four birds, two fish, two lizards and one rabbit. Most of these pets are dead and reside in plastic containers in the back closet. Those that are alive reside in the middle of my bed. Tomorrow I hope to get two more dogs. Oh, and two goats.

If I weren't so gorgeous, you would think I'm a huge pain in the butt because I'm such a liar.

The stories I've experienced in my 79 weird and wonderful jobs—machinist software engineer, executive management consultant, film festival director, envelope stuffer, chicken plucker, stripper, pothole counter, necktie folder, reporter, cookie packer, tool & die maker, life coach, comedy traffic school instructor—continue to find themselves expressed in nasty poems and sad comedy routines with elements of insanity.

A few of my screenplays and TV pitches are in talks with producers, so you (and I) can look forward to me being snarkily famous one day.

Sign up for my mailing list for announcements of new books or subscribe to my RSS feed for short, infrequent blogs www.MichelleShy.com or follow me on Twitter @MichelleShy

.

IF YOU LIKED THIS BOOK

Please leave me a review and rating at the retail site where you purchased the book. Thank you.

My email list and blog feed
www.michelleshy.com

Twitter: @MichelleShy

DOGKU, CATKU MUGS AND T-SHIRTS

ALSO BY MICHELLE SHY

As **DogKu, CatKu and WhatHaveU** *goes to press, my first book* **SnarkyKu** *has an average reader rating of 5 stars.*

The following books are coming soon:

PolitickKU

The world is in a mess and I'm writing snotty haiku about it.

Short Attention Span Poetry

Poems that, like little snacks, can be gobbled up in under a minute each

A Crazy Cat Lady

Focus on the "crazy"; these mini poems are just plain nutsoid

AngstKu

Yeah, these are all about angst, depression, pain, death and misery

FREE DIRTY, LITTLE, SNEAK PEEK INSIDE MY NEXT BOOK

Senryu 325:
Stealing is not right
Twenty percent interest rate
Isn't that stealing?

Senryu 328:
Family budget
Argue shout cry yell cry blame
Let's skip it this month

Gogyohka 3:
Starbucks is posting
Calories
Who cares
I need Starbucks
To post jobs

Senryu 434:
My boss' baby
Stupid, ugly and smells bad.
I say, "Oh, he's cute!"

www.ingramcontent.com/pod-product-compliance
Lightning Source LLC
Chambersburg PA
CBHW021037180526
45163CB00005B/2161